A Mark Dahle Portfolio

Race Day

Mark Dahle Portfolios can be read in a few minutes and enjoyed for a lifetime.

This portfolio includes a story about a man going on a long, grueling race, a photo of a gorgeous 36 x 24 inch painting (at the right) and twenty-five beautiful industrial photographs from Minneapolis.

Unlike many picture books, the text is unrelated to the painting and photographs. This might seem a little weird at first. One thing that helps is to order more portfolios until you get used to it. In the meantime, feel free to draw your own pictures of Derek's family on the pages if you like.

Photographs in this book are available in limited editions. See http://www.MarkDahle.com for more information and for previews of upcoming portfolios.

© Mark Dahle 2013. All rights reserved.

~ ~ ~

Derek was going to run a race.

He had heard two things about it:
1) It was long and grueling.
2) People who finished *never* regretted it.

He was excited
about being able
to participate in it.
He was looking forward to the race,
even though he knew it would be difficult.

He hoped he'd be able to finish.

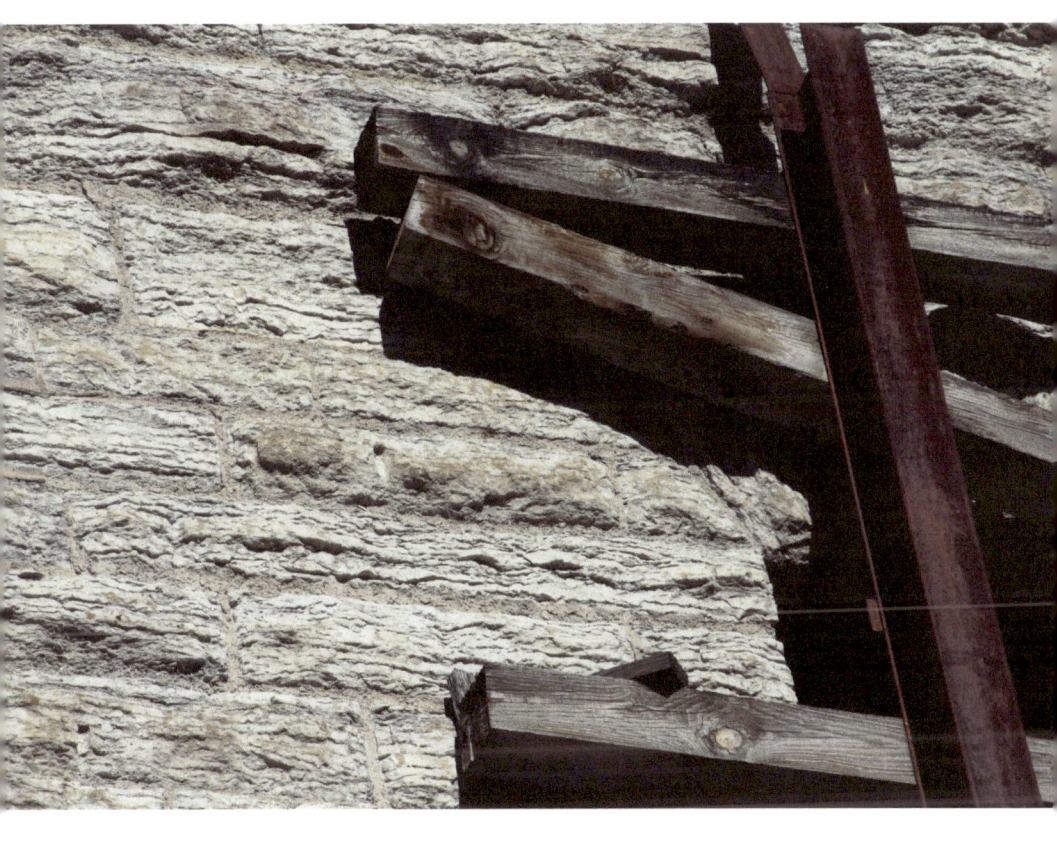

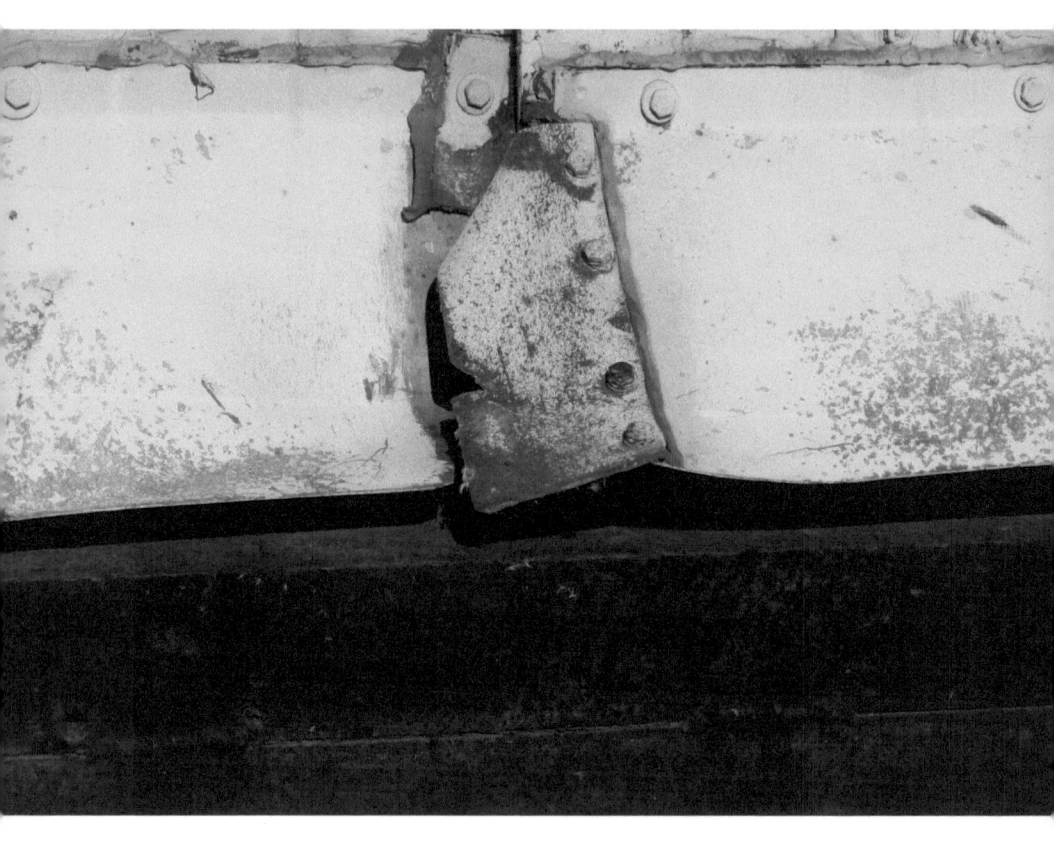

As he was thinking about the race, his parents phoned.

"Hi mom! Hi dad!" he said.
"I'm going to run a race."

"We heard, dear."
That was his mom.

"That's why we called.
We're very concerned for you.
We heard it was a long, grueling race.

"Are you sure you can make it?
What if you get hurt?"

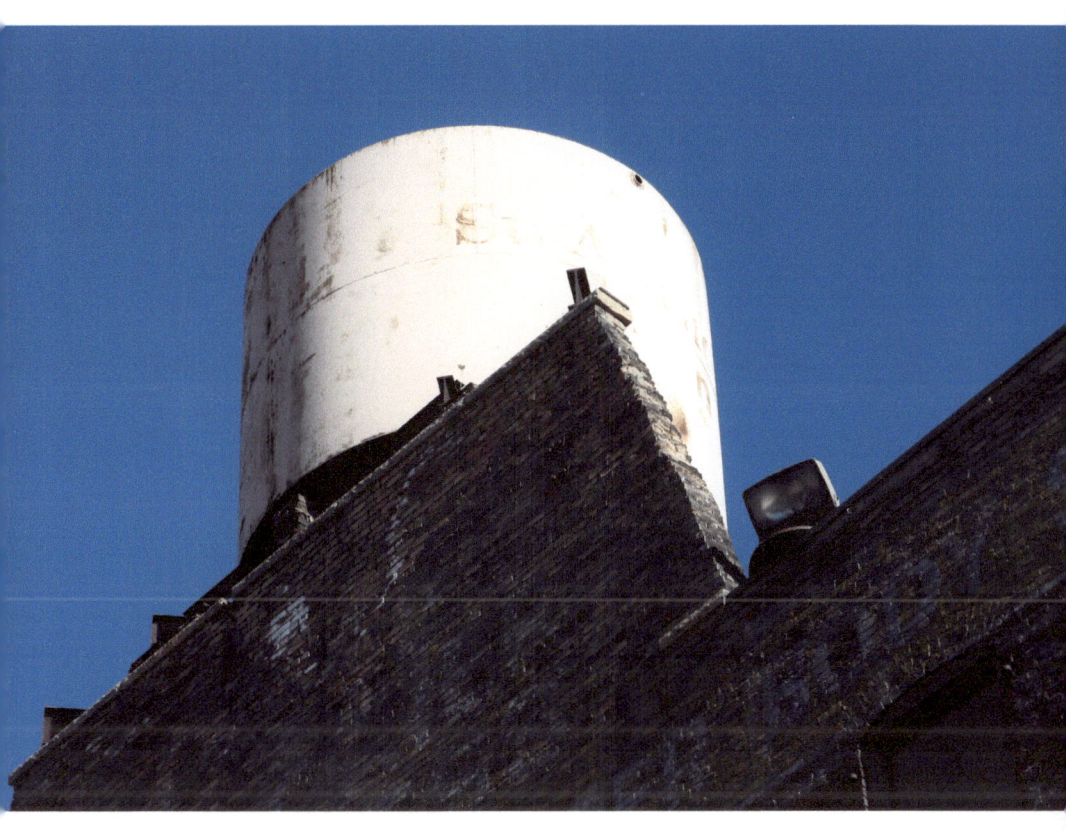

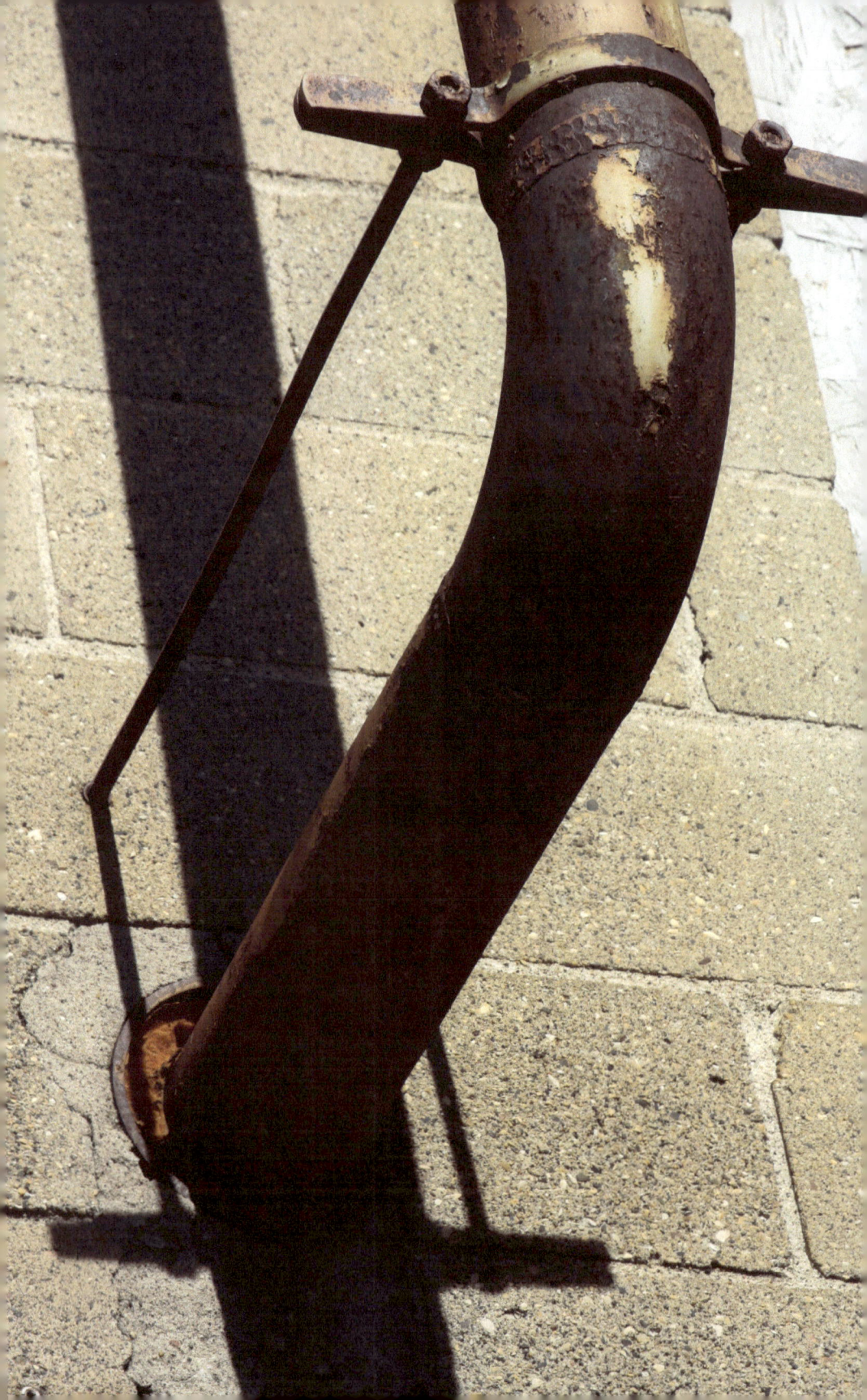

Derek could hear the anxiety
in his mom's voice.

He picked up a little of the anxiety
in his hand
and started to look at it
as she talked.

He hadn't thought
about what he'd do if he got hurt.

He had been so focused on running well
that it hadn't occurred to him
to think about getting injured.

But now that his mom was talking,
he started to wonder:
What if something happened?

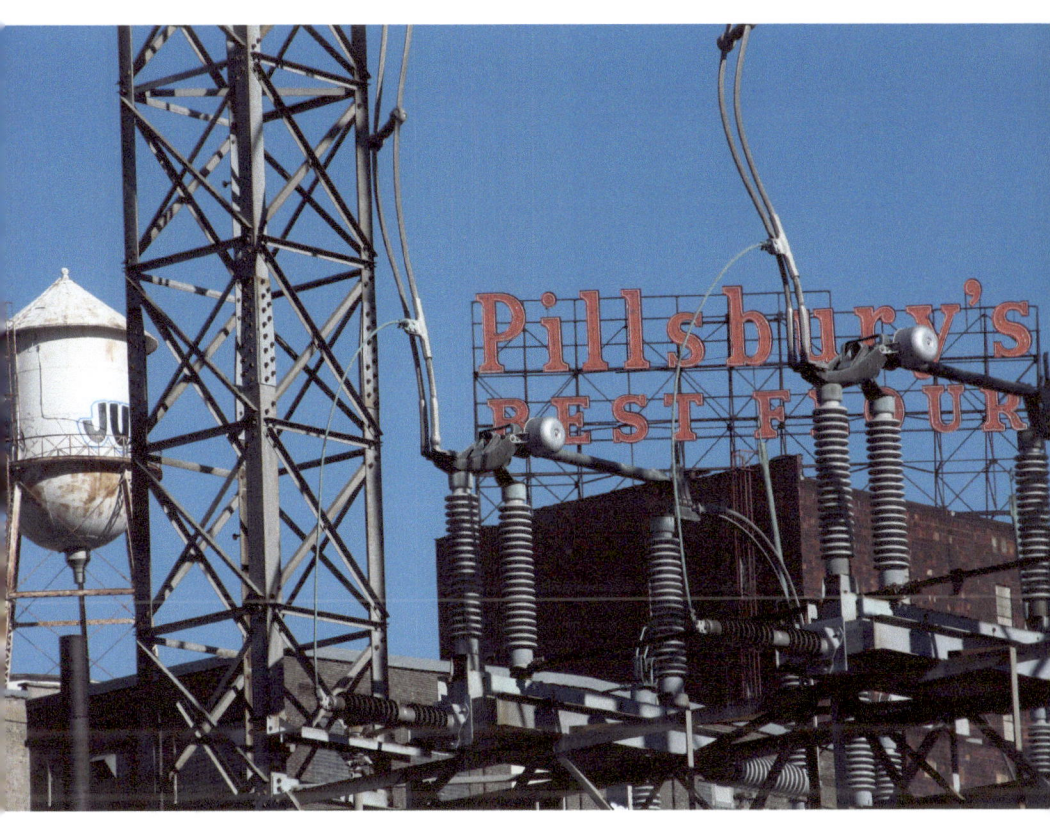

While Derek and his mom talked,
Derek's dad was silent on another extension.
Derek could tell from the silence
that his dad was worried, too.

Derek told his mom and dad
that he'd be fine.
He said it was a long, grueling race,
but that it was a wonderful opportunity
and that he'd do well.

"People who finish *never* regret it," he said.

When he hung up the phone,
he found he hadn't completely let go
of all of his mom's and dad's anxiety.

He was still carrying some of it.

For some reason he couldn't put it down.
At least not yet.

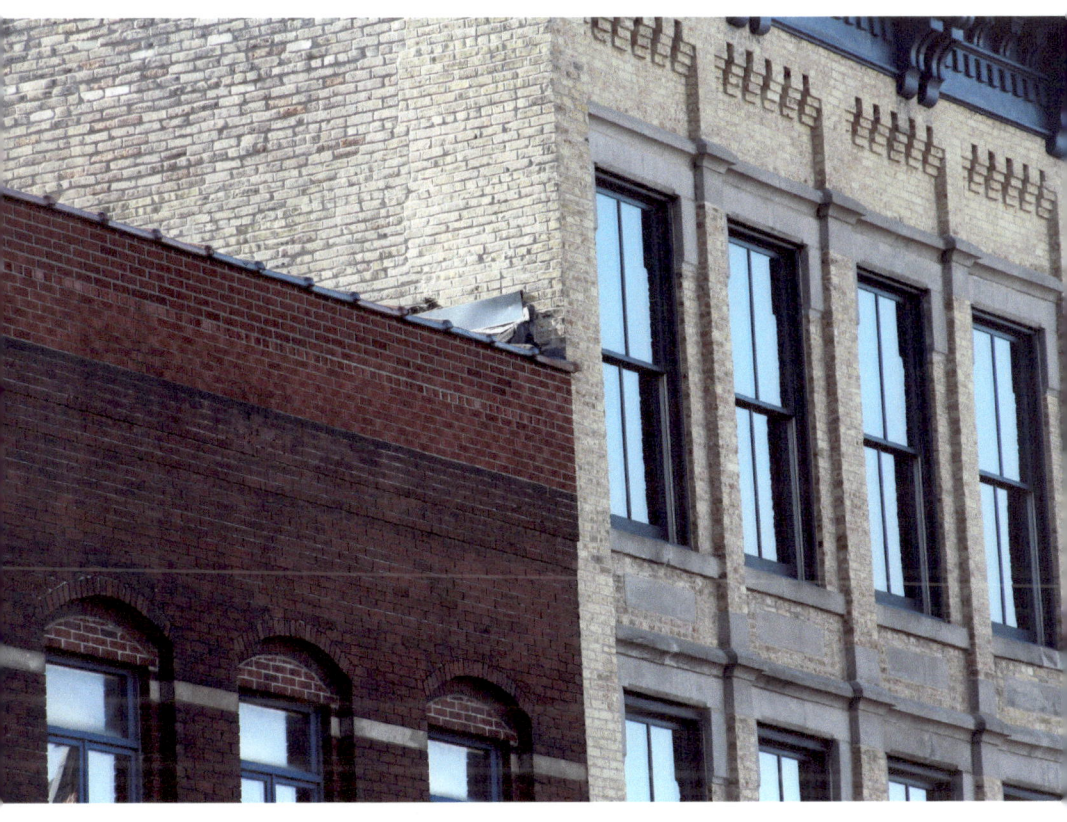

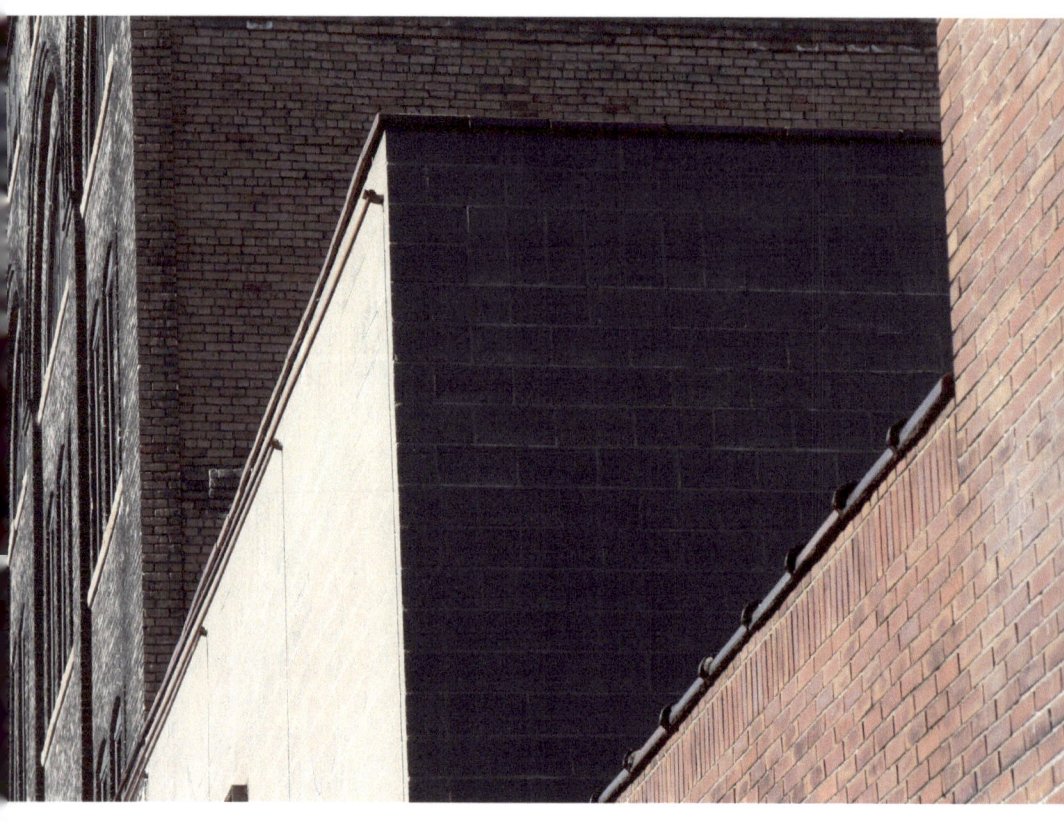

The day before the race,
Derek's four-year-old son came up to him.

"Why are you going?" he demanded.
"Are you coming back?"

Derek laughed.
"Of course I will.
I'm going to be in a long, hard race.
But I'm not leaving you.
Of course I'll be back."

But as he said it,
Derek realized he wasn't so sure.

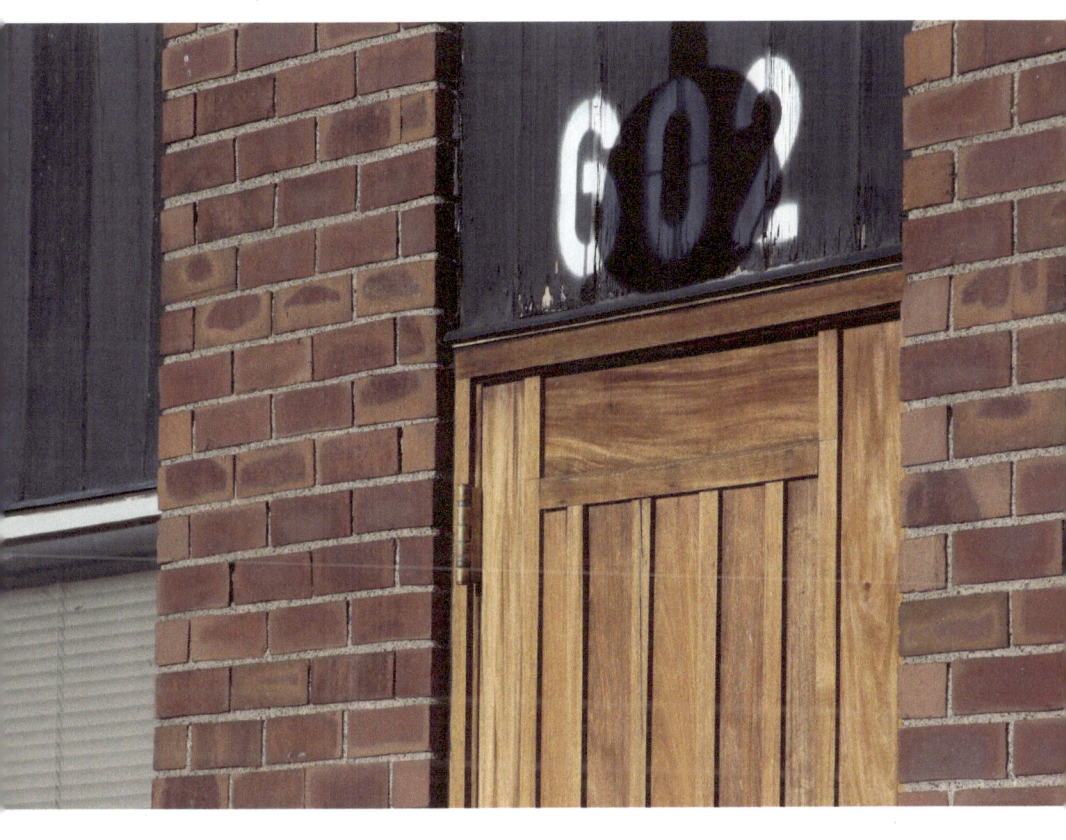

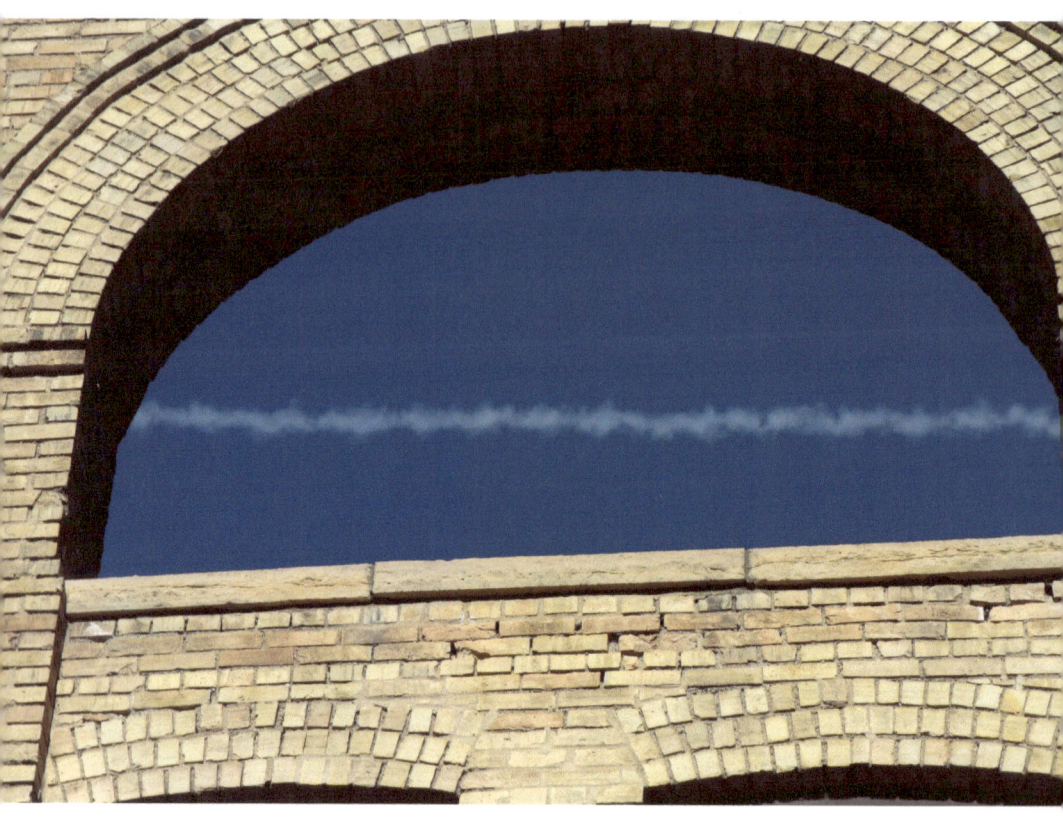

Derek hadn't thought about it,
but he remembered that every now and then,
someone died in the race.

What if Derek *didn't* make it?

And even if he came back
right after the race ended,
what would his son do
while he was running?

After a minute or two,
Derek realized he'd picked up
some of his son's fear and hopelessness.
He was still carrying his parents' anxiety.

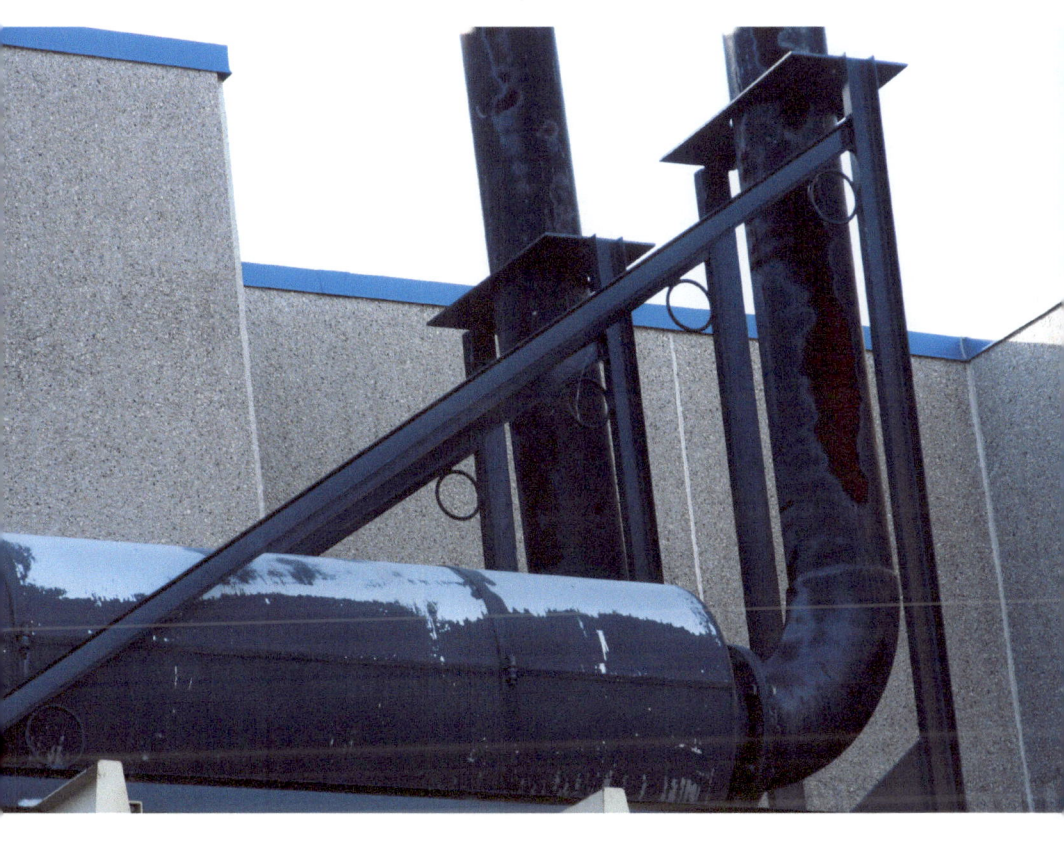

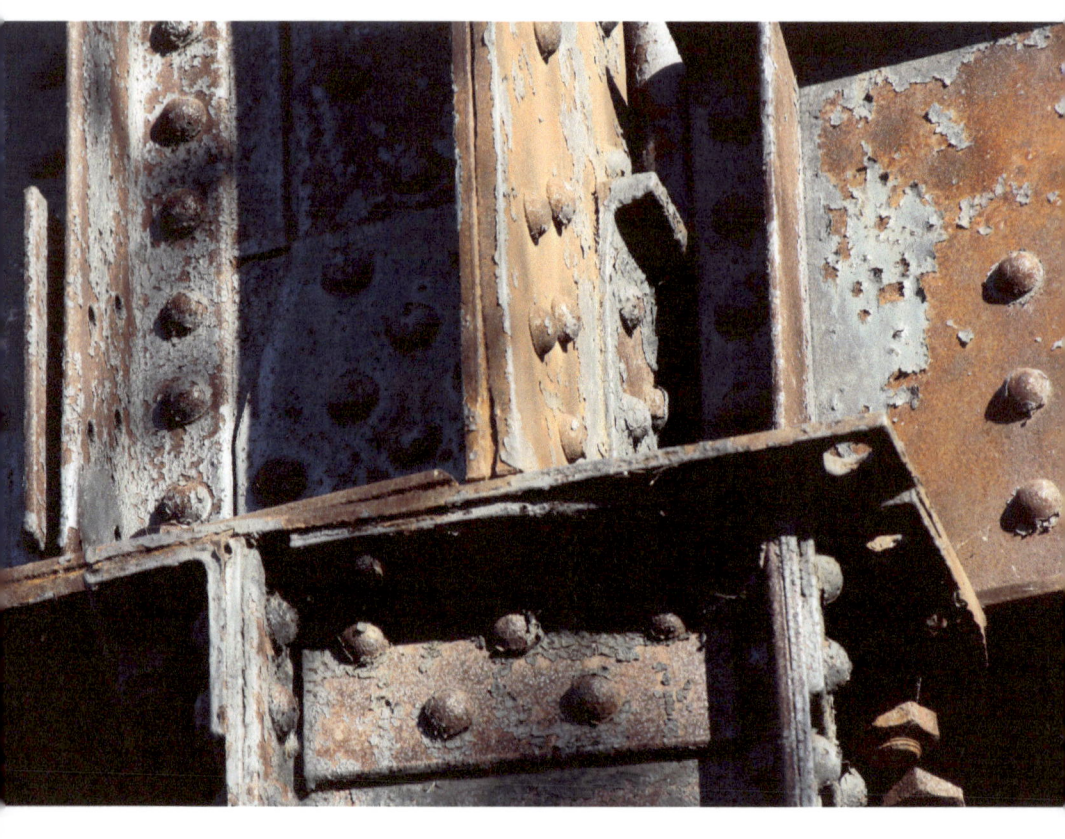

That afternoon Derek's wife Mia
was busy in the kitchen.

She cooked and cleaned
until the kitchen was spotless.

She got like that when she was bothered.

When Derek saw that she'd spent all day
cooking his favorite meal,
he knew something was up.
But Mia didn't say anything.

When they were picking up the dishes after dinner,
he finally brought it up.

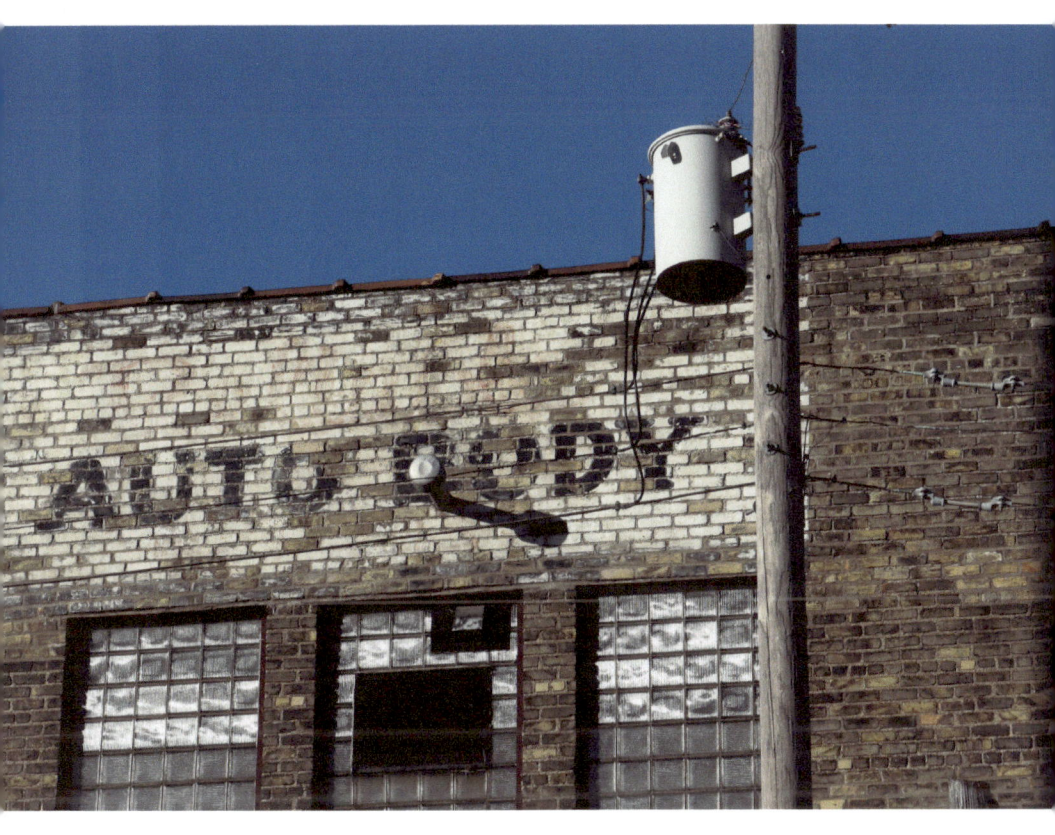

"That was a wonderful meal, honey.
I wonder what you
were thinking about today."

This was either exactly the right question or exactly the wrong one.

Mia burst into tears.

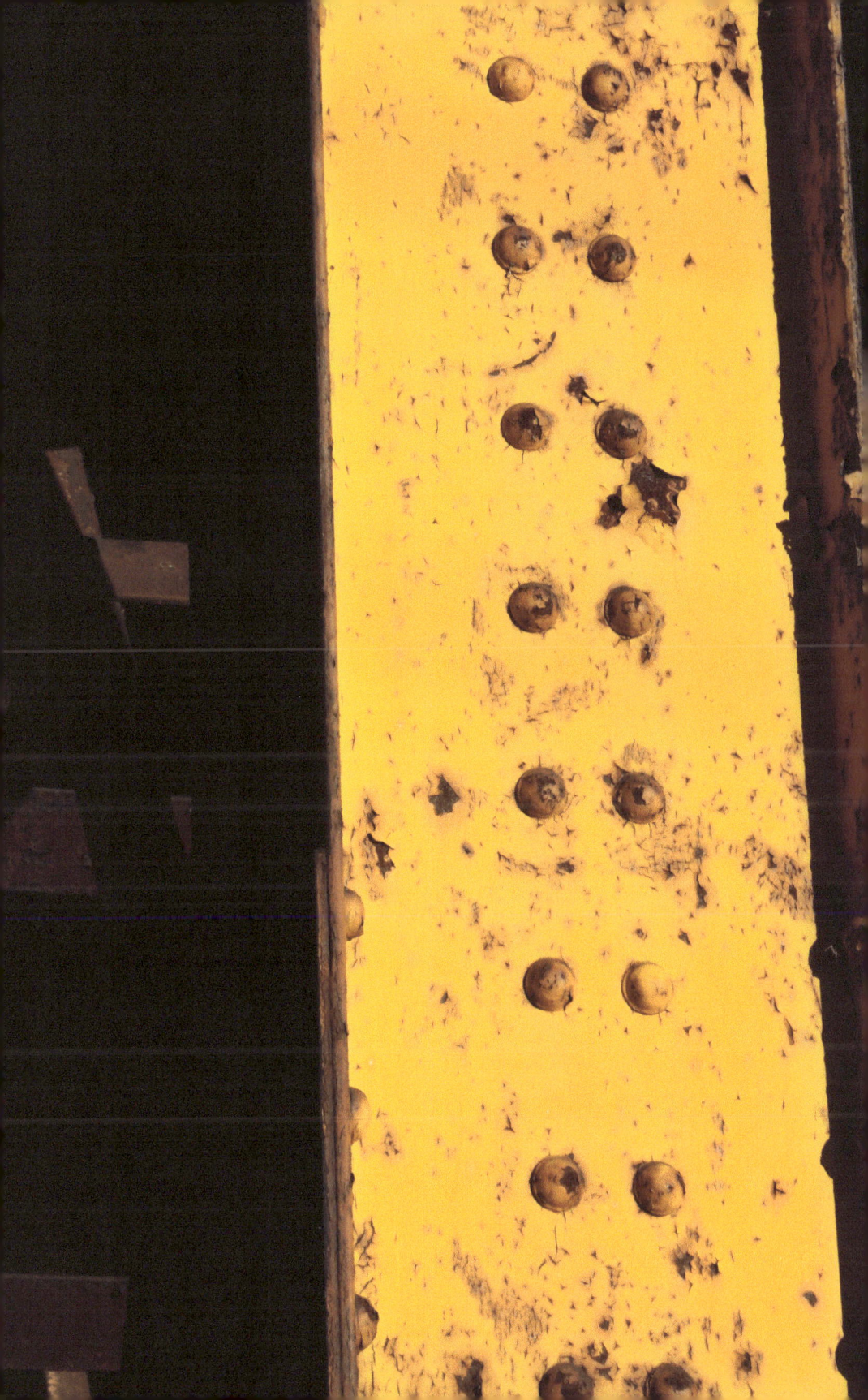

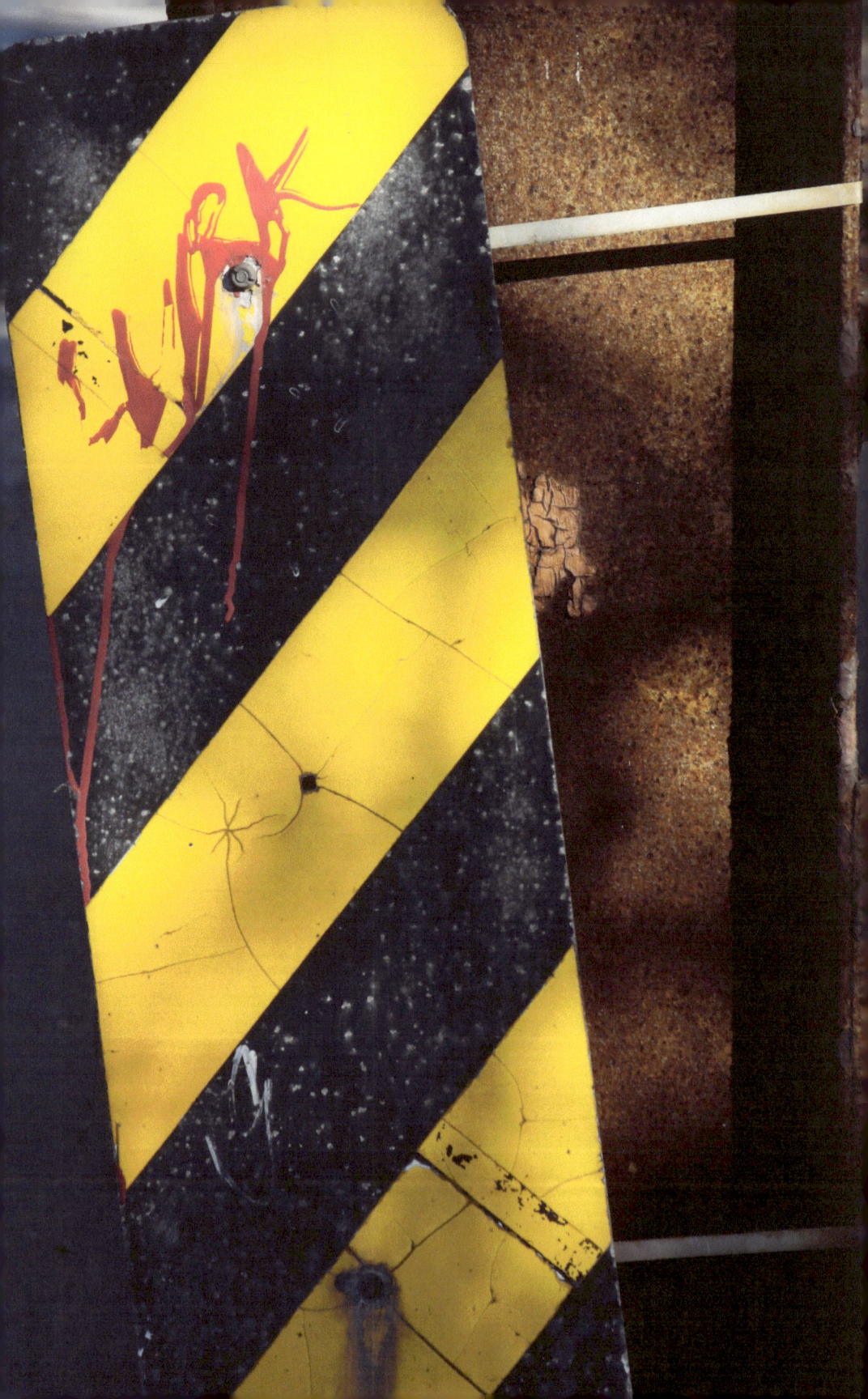

The accumulated strain of the day
completely overwhelmed her composure.
Her breath came in gasps as she sobbed.
Finally she got out the words,
"You – don't – love – me – anymore!"

Derek was shocked.
Where was *that* coming from?
Of course he loved Mia.
But there she was, weeping.
She obviously didn't think so.

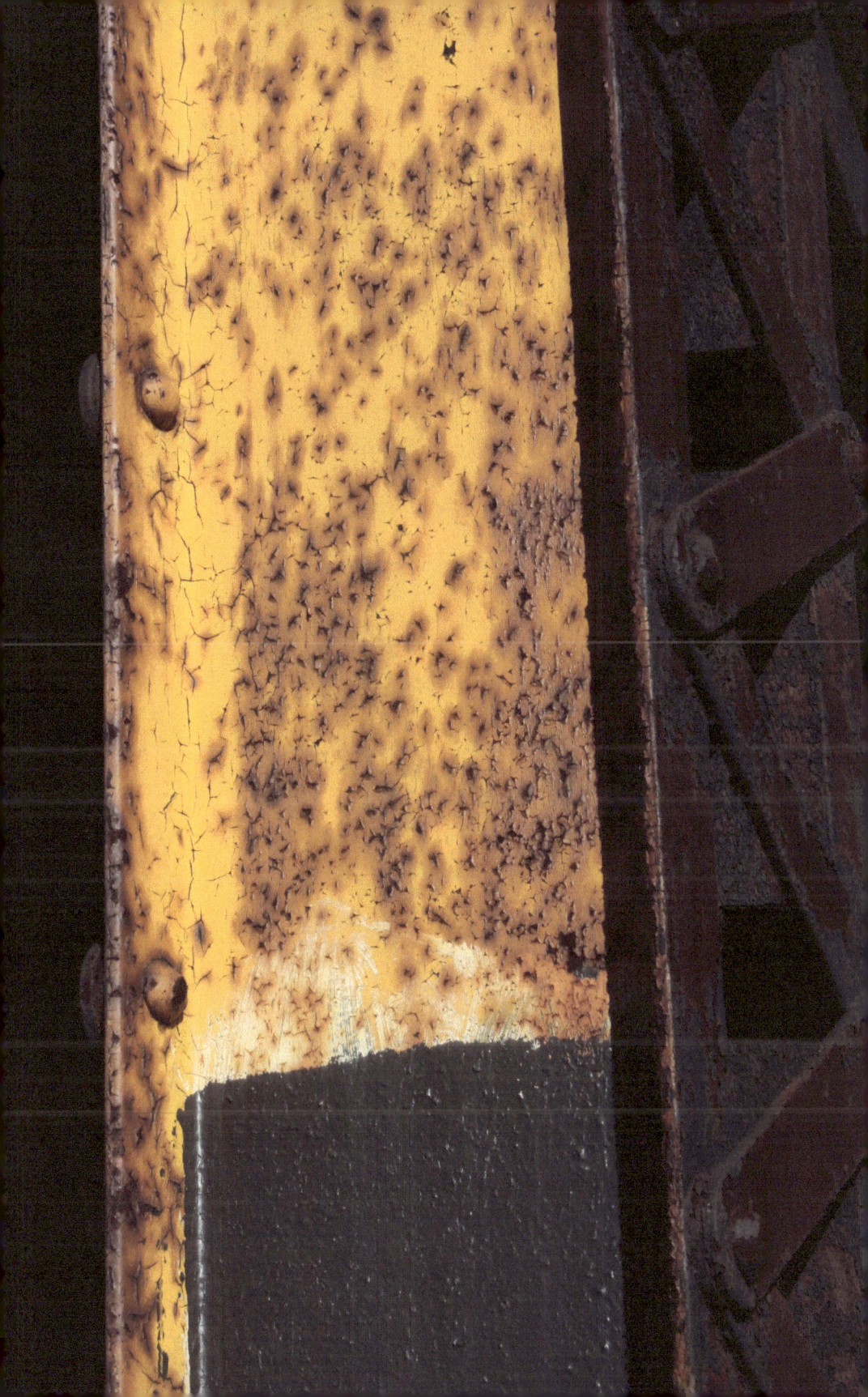

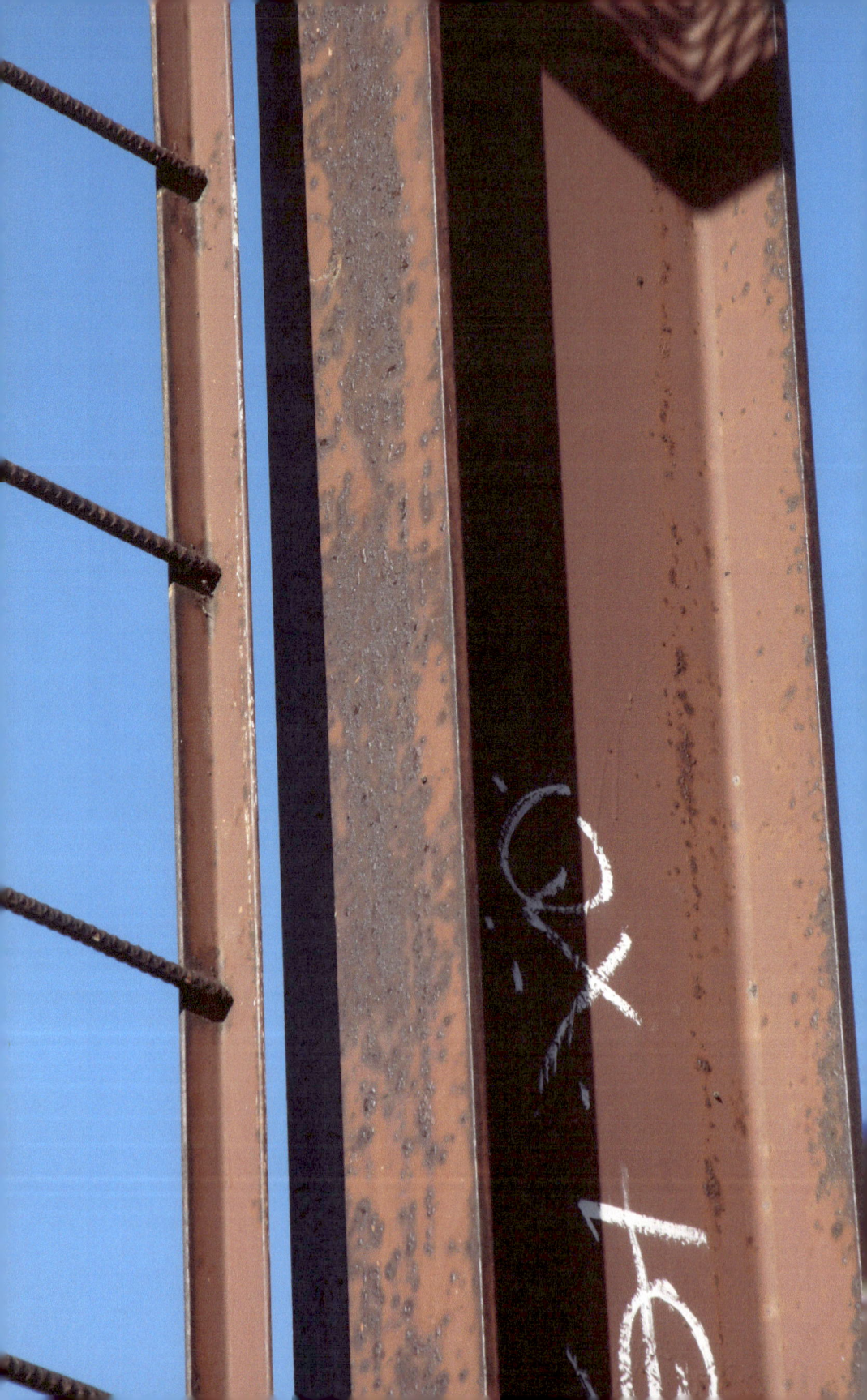

At last she blurted it out between sobs:
"You're going on that race.
And you know I can't go.

"Derek, how *could* you go on that race
when you know I can't go with you?"

Now this was something
Derek hadn't thought about, either.

And it wasn't exactly true.
Mia *could* have gone if she had wanted to.
She was a very capable person.
She *was* able to do things
that were difficult.
After all, she'd been raising their four-year-old.
But when Derek had talked about the race
she'd consciously chosen not to enter.
Now she was crying that she'd be deserted
while Derek participated.

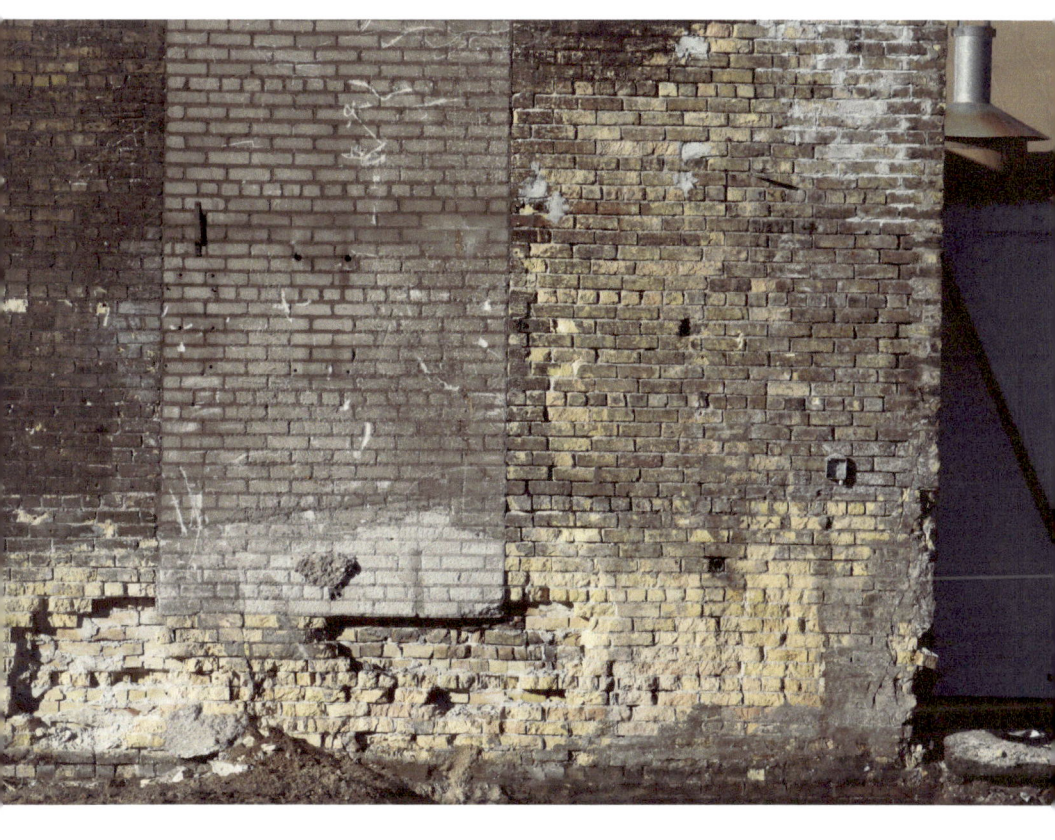

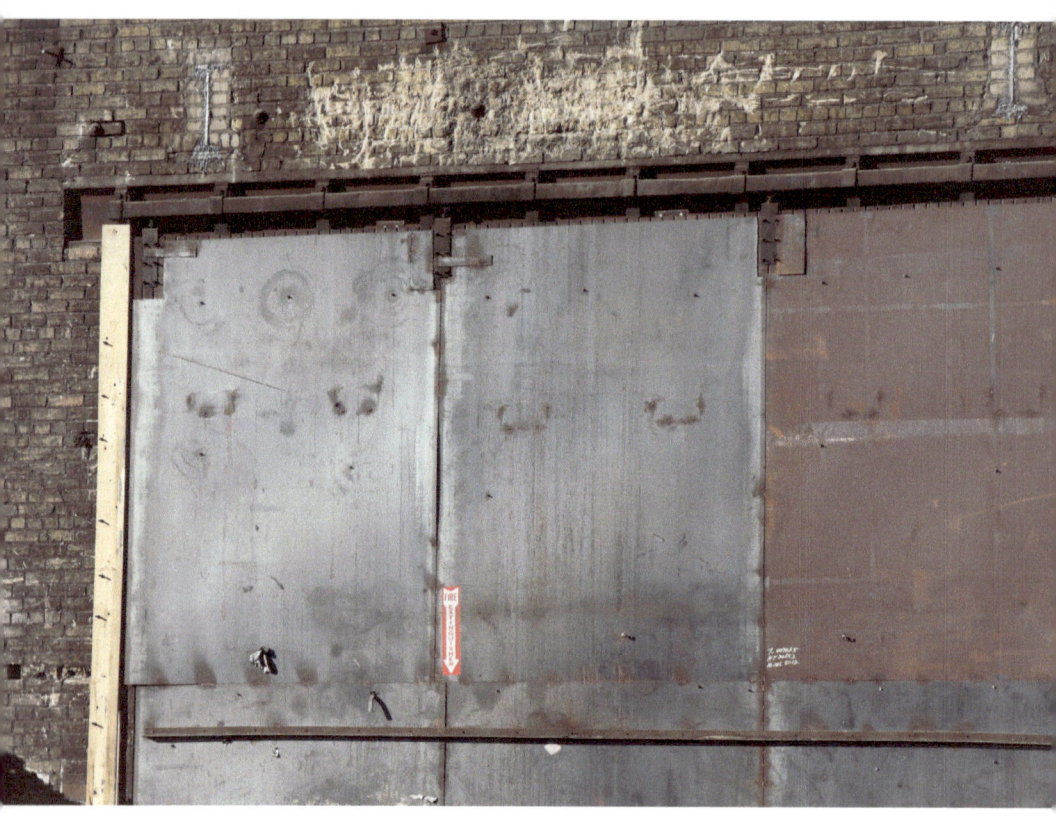

Derek tried to tell her that he loved her.
To prove it, he picked up
some of the loneliness
and feeling of abandonment
that she had been harboring
and offered to carry it for her.

At 5 a.m. the next morning, Derek's alarm clock went off.

The day of the race had arrived.

~ ~ ~

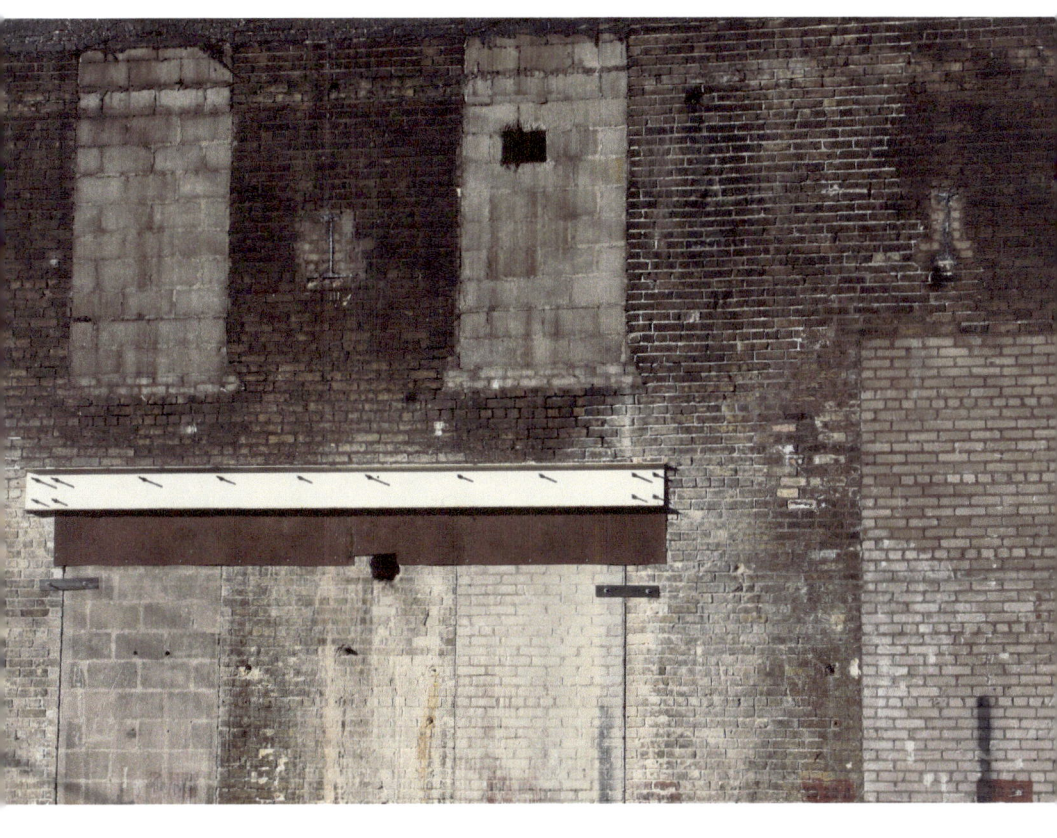

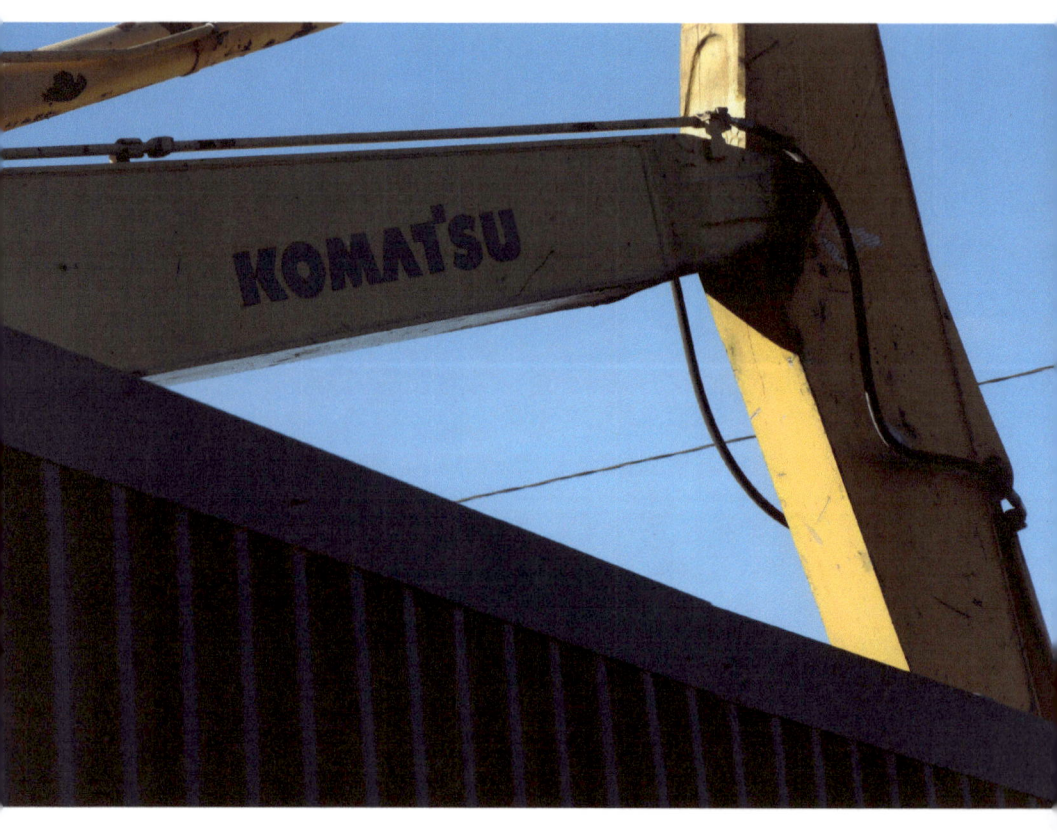

Reflection Questions

Will Derek be able to finish
the long, grueling race
carrying his parents' anxiety,
his wife's loneliness and feeling of abandonment,
and his son's fear and hopelessness?

If people can barely finish the race
without carrying *any* weights,
how will Derek make it carrying such a load?

And what (if it's not too impolite to ask),
what are *you* carrying
that belongs to someone else?

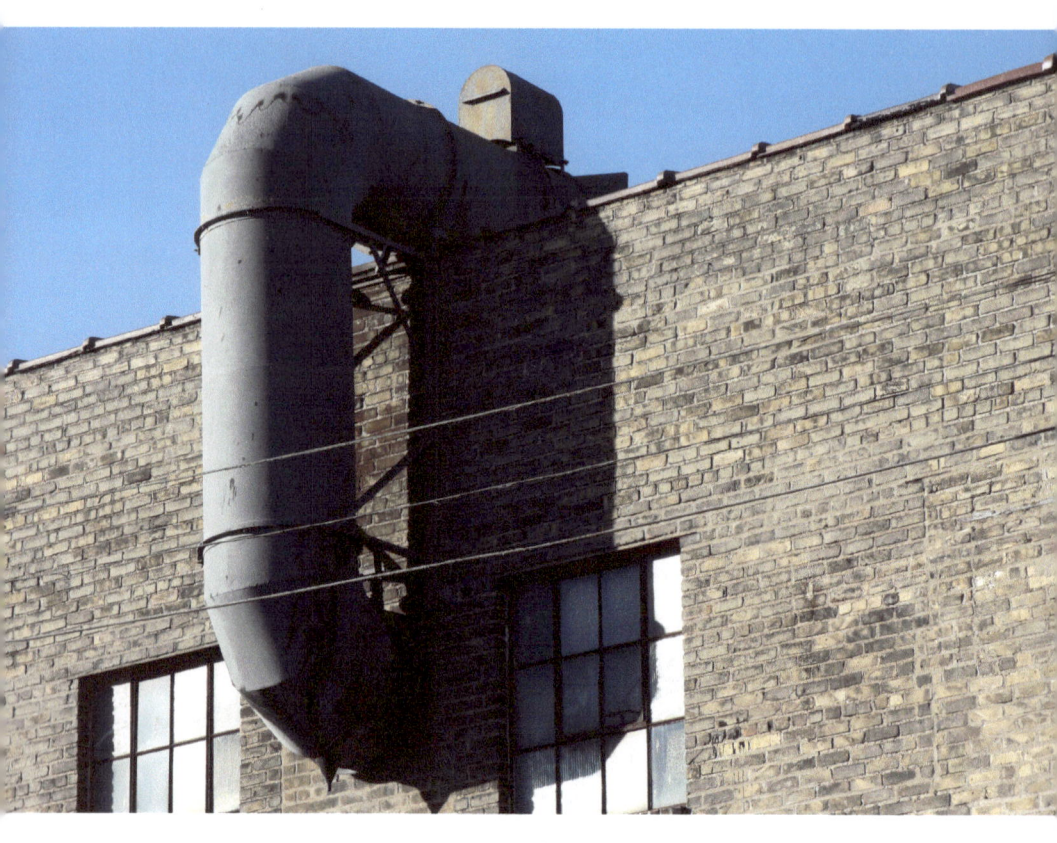

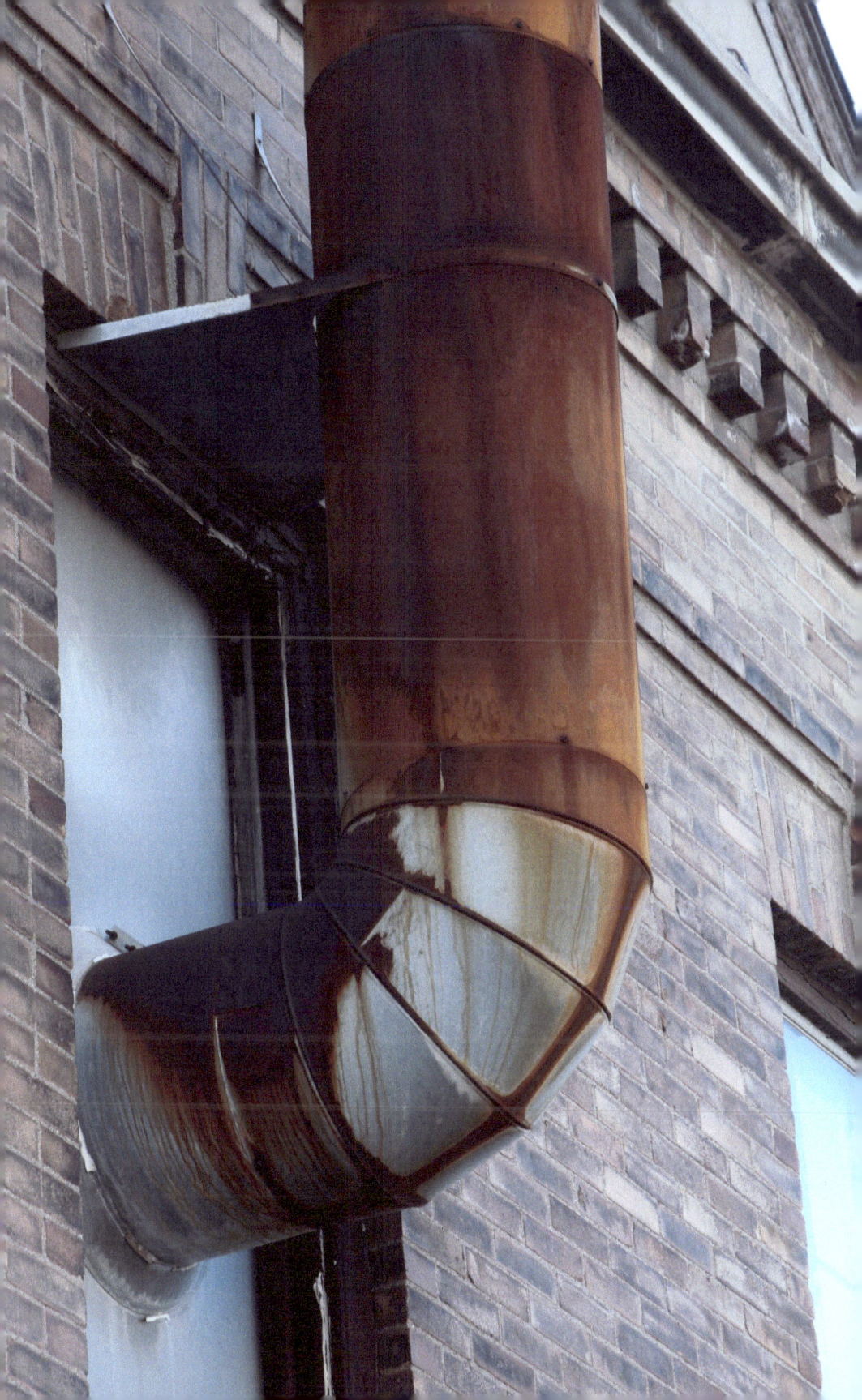

A Mark Dahle Portfolio

An Assignment From Hell

This Mark Dahle Portfolio includes a gorgeous painting, twenty-six beautiful photographs of electric utilities, and a story about America's wealth.

When you're in hell, you don't want to be called into the boss's office.

No matter how it goes, you always know that no good will come of it.

A Mark Dahle Portfolio

Hungry

This Mark Dahle Portfolio includes a beautiful painting from Mark Dahle's Stop and Go series, twenty-five outstanding photographs from Amsterdam and San Diego, and the mouth-watering story of a hungry girl on Thanksgiving Day.

> For some reason,
> even though Sally is hungry,
> she doesn't believe the call is for *her*,
> at least not right now.

This Mark Dahle Portfolio includes a painting, twenty-seven beautiful industrial photographs of Redding, CA, and three very short commentaries: The Man Who Liked To Dream, Hiking To The Middle, *and* Disappointment.

Once there was a man who had everything he wanted all planned out. He could picture it when he closed his eyes. So that's what he did. He lay down on his bed and closed his eyes every chance he could.

A Mark Dahle Portfolio

The Man Who Liked To Dream

www.ingramcontent.com/pod-product-compliance
Lightning Source LLC
Chambersburg PA
CBHW041109180526
45172CB00001B/171